Ex Libris

Raven's Key Journal

Copyright © 2014 by Mary Layton

Cover art and interior design by Mary Layton

All rights reserved. No part of this book may be reproduced in any form by any electronic or mechanical means including photocopying, recording, or information storage and retrieval without permission in writing from the author.

www.marylayton.net

www.ingramcontent.com/pod-product-compliance
Lightning Source LLC
Chambersburg PA
CBHW071425170526
45165CB00001B/399